COLORFUL
Inspirations

Jess Volinski

DESIGN ORIGINALS
an Imprint of Fox Chapel Publishing
www.d-originals.com

Be Yourself to Be Creative

The thing I love most about art—making it myself or enjoying others' creations—is that art allows you to be yourself by expressing yourself. Whatever you love, whatever is important to you, whatever makes you who you are should come out in your art. By making art that matters to you, you're starting a conversation with everyone who sees it.

You might be wondering, how exactly do I express myself with art? That's where The Elements of Art come in! You might remember these from art class. Just like writers use words to tell a story, artists use these visual elements to express themselves and start their art conversation. All visual art—whether it is a painting in a museum, storyboards for a movie, a pattern on a bag, or a coloring book page—uses some combination of these seven basic building blocks of art. Not all art has to include all seven elements, but most art will include a few.

The Elements of Art

A **line** is formed as the connected distance between two points. Lines can be thick or thin, straight or curved.

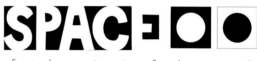

Space refers to the areas in a piece of art that are around or within different parts of the art. There are two kinds of space: negative (space around areas), and positive (space within areas).

A **shape** is a defined area of space—a circle, square, blob, or a flower petal are all shapes.

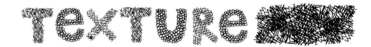

Texture refers to the way the art physically feels when touched, or how an artist visually makes the art **look** like it would feel. Shading with pencils is an example of this type of visual texture.

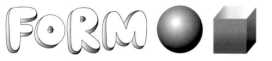

Something has **form** if it has volume (or creates the illusion of volume). A three-dimensional sculpture has form. A two-dimensional drawing with shading that makes it appear three-dimensional can also have form.

Color is created when light hits an object and is reflected to our eyes. A color can be described with three properties: hue (the color's name, such as "red"), value (how light or dark the color is, also called a tint or shade of the color), and intensity (how vivid or dull the color is).

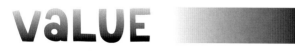

Value refers to the relationship between light areas and dark areas in a piece of art.

Let's look at one of my drawings and see what Elements of Art are here. Even though this is just a simple black and white drawing, it has line, shape, and space. When you color it in, you'll probably add form, color, value, and maybe even texture. That's all seven Elements of Art.

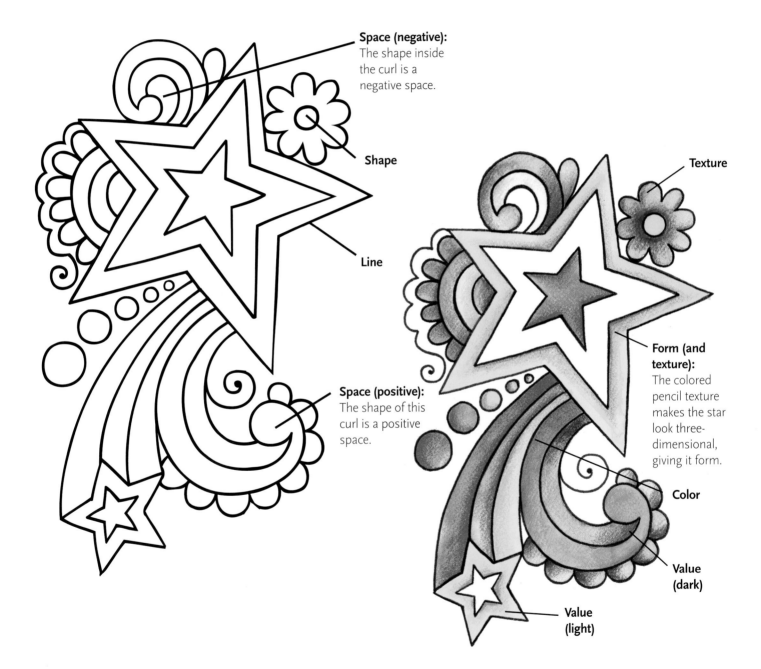

Space (negative): The shape inside the curl is a negative space.

Shape

Line

Space (positive): The shape of this curl is a positive space.

Texture

Form (and texture): The colored pencil texture makes the star look three-dimensional, giving it form.

Color

Value (dark)

Value (light)

Get Inspired by Color

When it comes to expressing emotion, I think color is probably the most powerful Element of Art. To me, there's no better way to express how you're feeling, or how you want someone else to feel, than through the use of color. Just think of some of your favorite memories and how they make you feel. I bet color plays a big part of what you remember. Whether it's a beautiful sunset, the green of spring after a long, cold winter, or a perfectly clean, white expanse of snow, color makes a huge impact on us, both visually and emotionally. Just look at the way different colors can give the same flower drawing a completely different feel!

I've found that planning is key when working with color. If you're like me and you just love color, it might seem a bit overwhelming to get started. There are just so many color choices! And it's easy to fall into the rut of using the same colors over and over again, just because you like them. Making color decisions before you start can make you feel comfortable using new colors. Plus, you won't have to make a choice when you're in the midst of coloring and decide you don't like the result as much as you thought you would. A great way to try some new color combinations is to take a few minutes to create your own palettes before you get started.

Here's a fun trick I've learned for making palettes. It works especially well if you're using markers or colored pencils. Lay out all of your markers (or pencils) on a table or floor so you can see every single color you have. Pick one favorite marker (pencil) that will serve as the anchor color for your palette. Make it a color you really enjoy working with (or for a challenge, maybe a color you never work with!). Now, pick two or three other markers (pencils) that complement your anchor color and place those next to your anchor color to start building a palette. Keep going until you have picked five or six colors. At this point, you don't even have to use them—you're just putting them side-by-side to see how the colors look together. Keep adding or switching colors until you like what you see. It's so easy to swap different colors in and out this way. Once you have a group of colors that you like, test them out on paper to make sure you still like the way they look together. If you love it, be sure to create a sample page with the names of the markers/colors you used so you won't forget. This is a great way to quickly create a whole library of color palettes for yourself.

Another great place to get color inspiration is literally from the world around you. Color is everywhere. There are probably patterns and designs with interesting color palettes surrounding you now! I'm sure there are things you bought because you liked the colors, so use those things that you love as inspiration. I once bought a pack of hair elastics simply because they had the most beautiful combination of blues and purples. Almost anything, anywhere, can become a color inspiration, so always keep your eyes open!

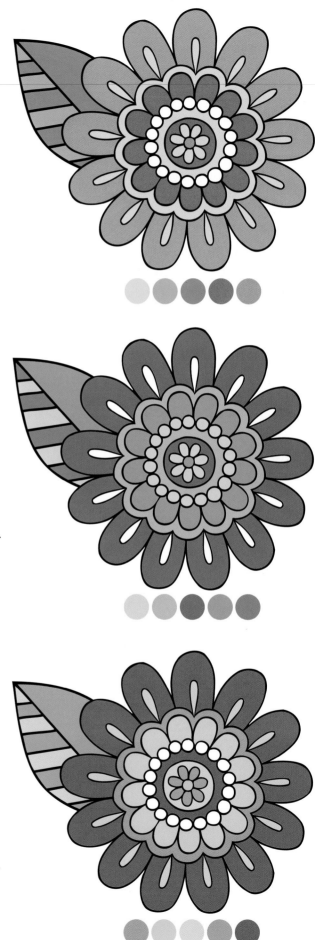

A Spectrum of Emotion

Color can be a great way to express yourself and define your mood. When you sit down to color, ask yourself, "How can I use color to express the way I'm feeling?" Sometimes you might even feel something you can't quite put into words, but you can express it with color.

I've included some of my favorite palettes on the following page. Each one is paired with the emotion that best describes how the color combination makes me feel. But keep in mind that everyone is different, and that's what makes art so exciting. I love to use bright colors, but maybe you like more subdued colors. My "relaxed" palette might be your "cozy." There is no right or wrong when it comes to color! Use these palettes as a starting point and see how they make you feel. Try adding or taking away a color to customize the palette to reflect your taste and style. Then, make your own page full of your favorite color palettes!

The next few pages contain some colored examples.

You'll see two color palettes on each page, one at the bottom and one along the outer edge. The palette at the bottom shows the design's main colors in the large circles. The small circles show lighter colors (called tints) and darker colors (called shades) of those main colors. This is to give you the feeling of this palette and visually show which colors are dominant in the design (the bigger the circle, the more dominant the color).

Along the outer edge of each page, I've included a palette with each individual color, shown separately, so you can easily match your marker, pencil, or paint colors to the colors I used.

Whether you use one of my palettes or create your own, always be sure the colors you choose reflect who you are and how you're feeling.

Now go gather up your art supplies—it's time to color!

The circles along the outer edge of the gallery pieces show you each individual color I used in that particular piece. If you like the palette I chose, you can use these circles to match the colors of your own pencils or markers.

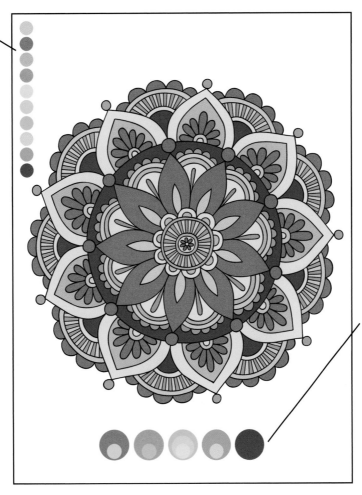

The circles along the bottom of the gallery pieces show you which colors are more dominant in each design. The larger the circle, the more dominant the color. The smaller circles show tints and shades of a main color that were introduced for variety

A Spectrum of Emotion

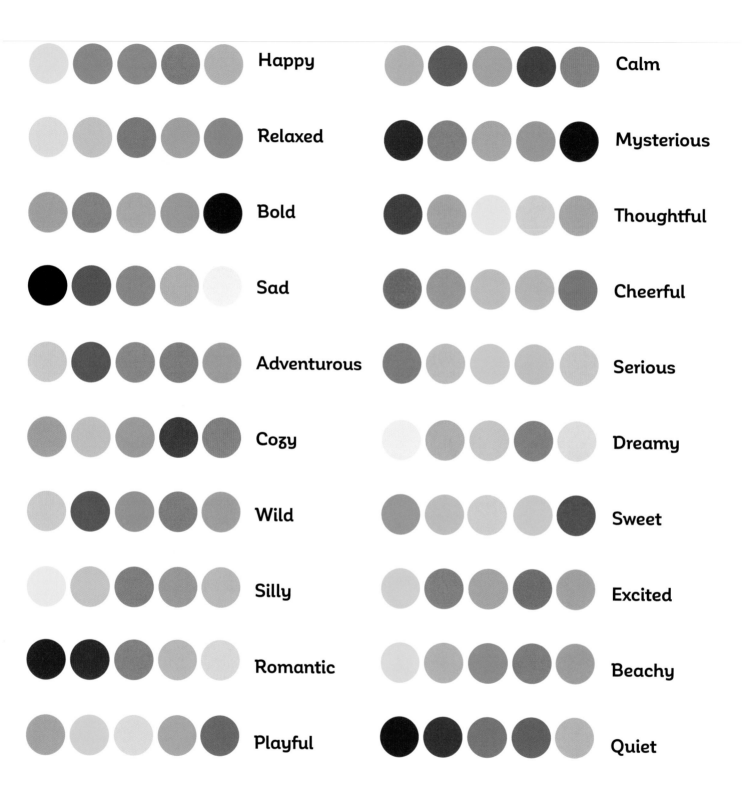

Happy

Relaxed

Bold

Sad

Adventurous

Cozy

Wild

Silly

Romantic

Playful

Calm

Mysterious

Thoughtful

Cheerful

Serious

Dreamy

Sweet

Excited

Beachy

Quiet

Your Wings
already exist.

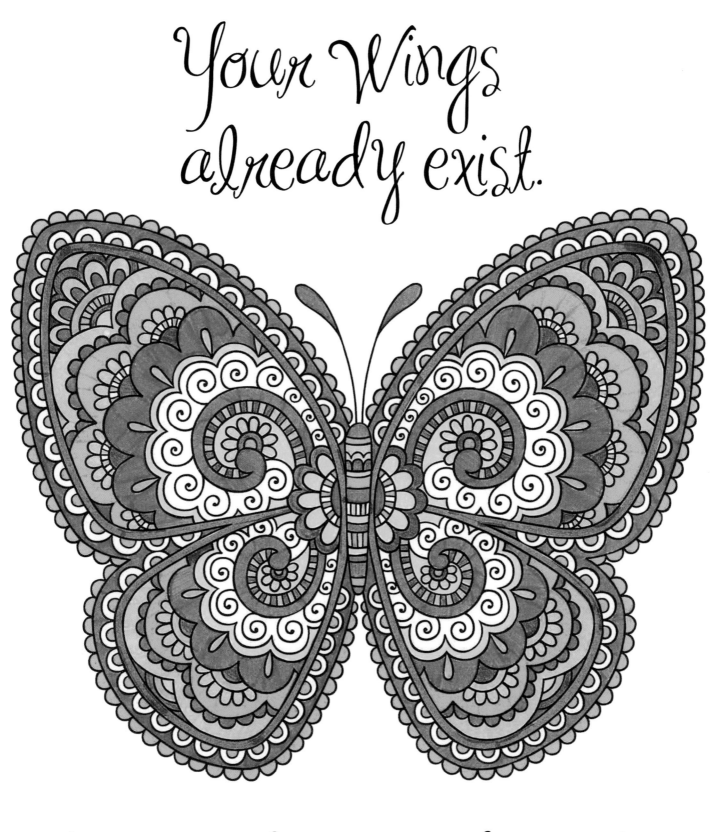

All you have to do is fly.

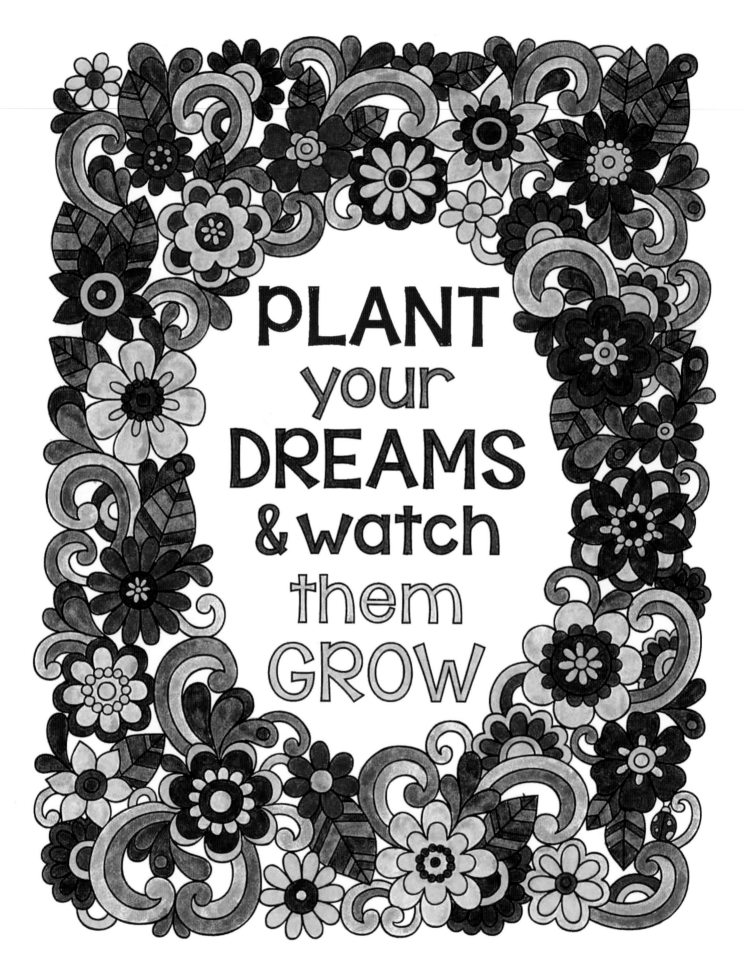

PLANT your DREAMS & watch them GROW

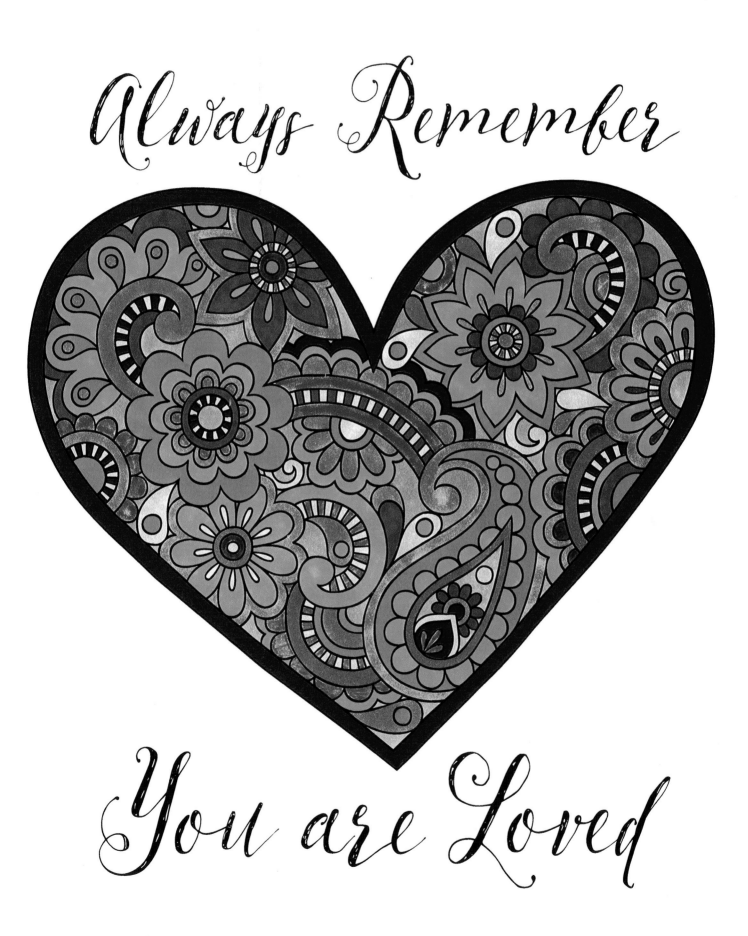

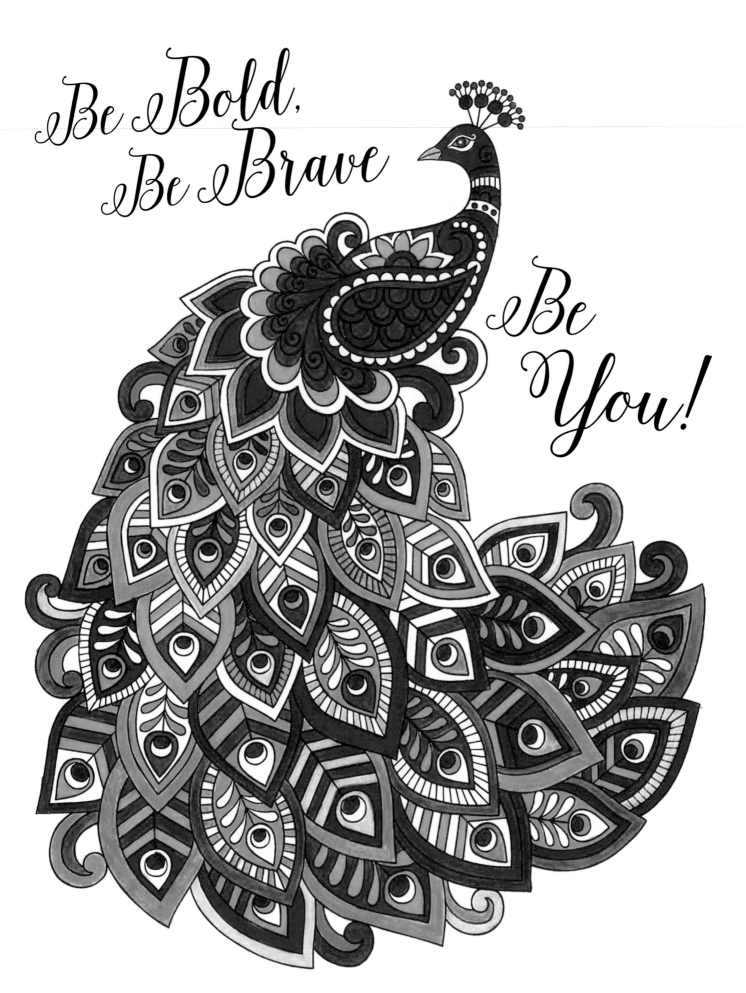

Be Bold,
Be Brave
Be You!

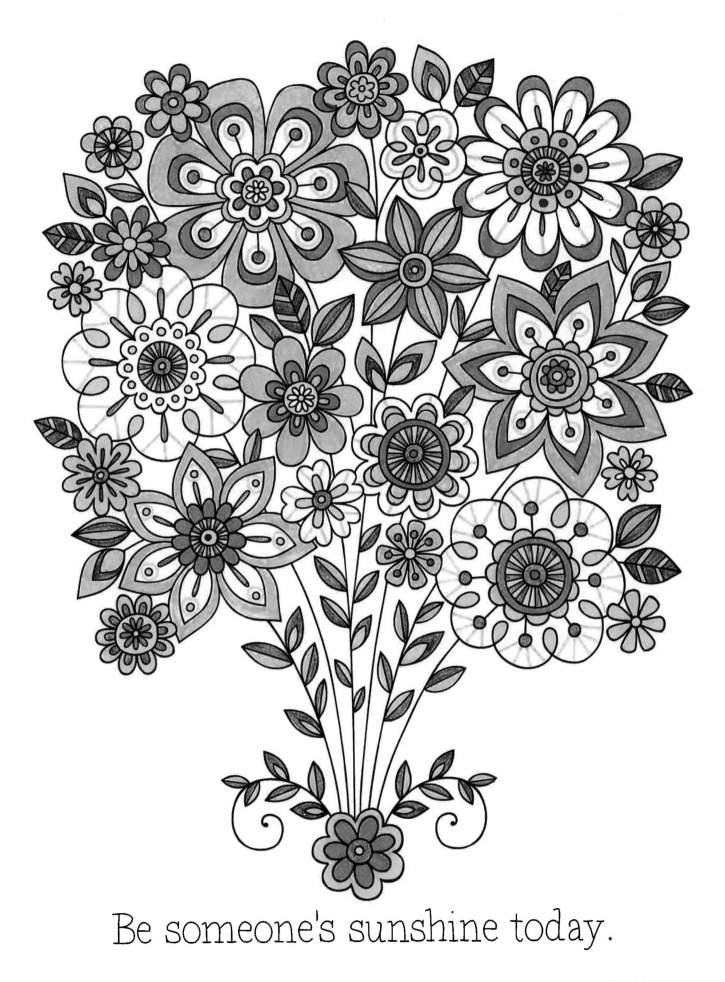

Be someone's sunshine today.

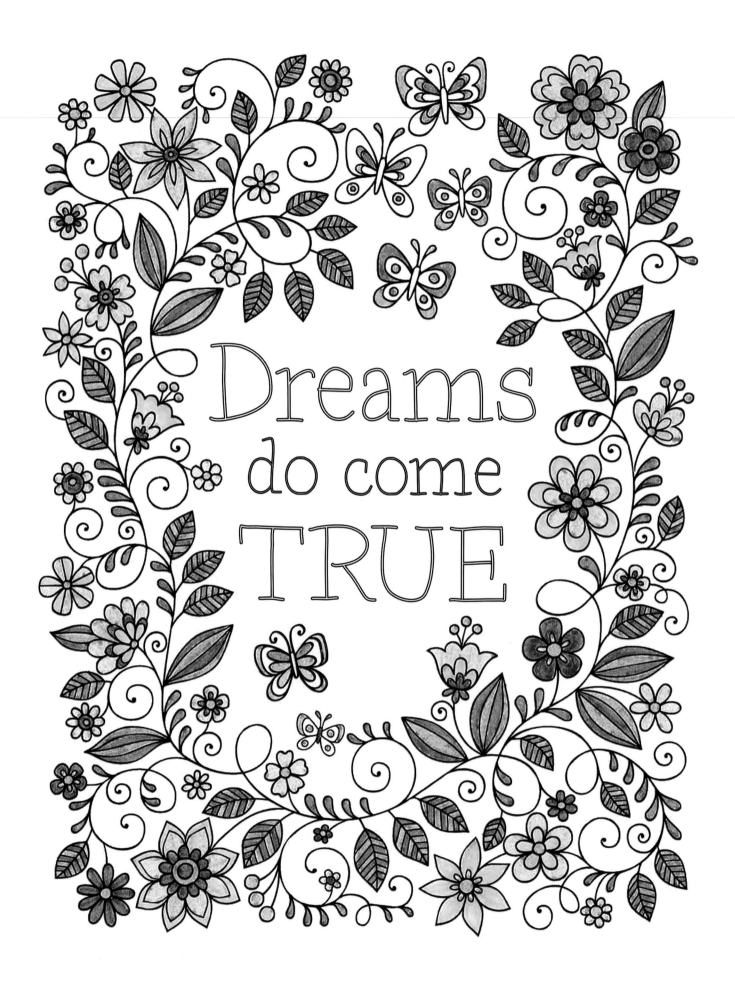

Dreams do come TRUE

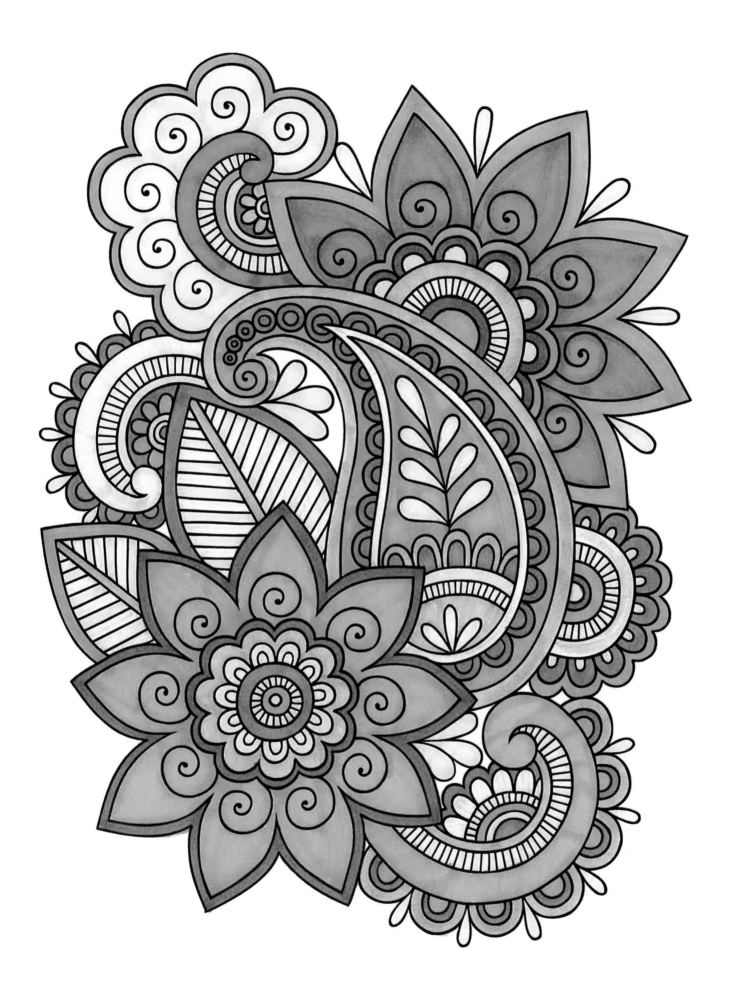

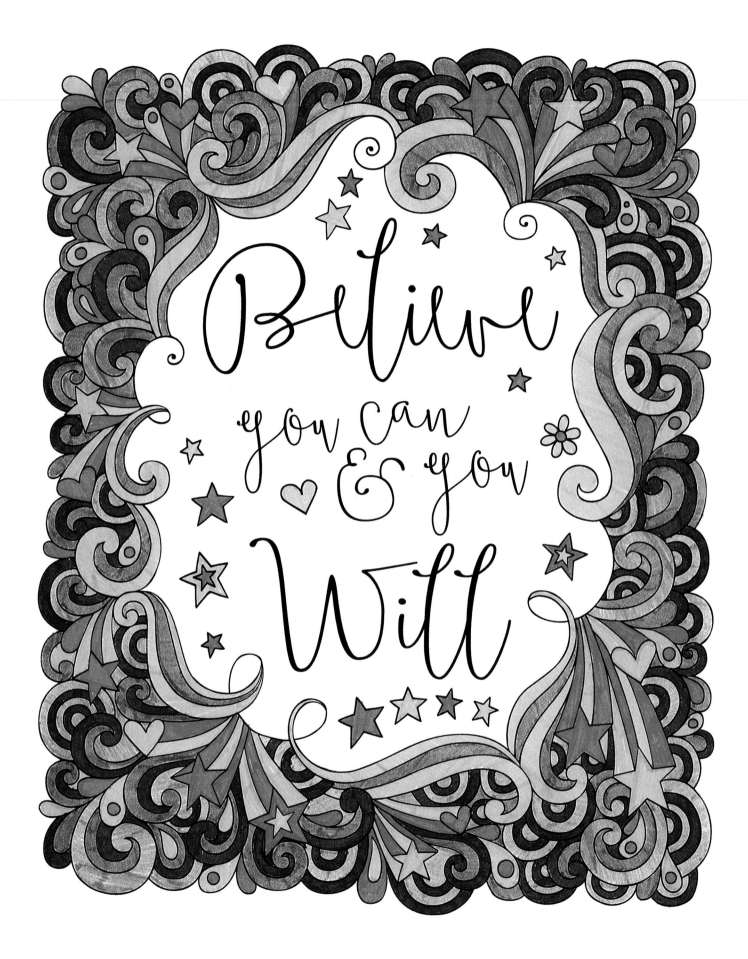

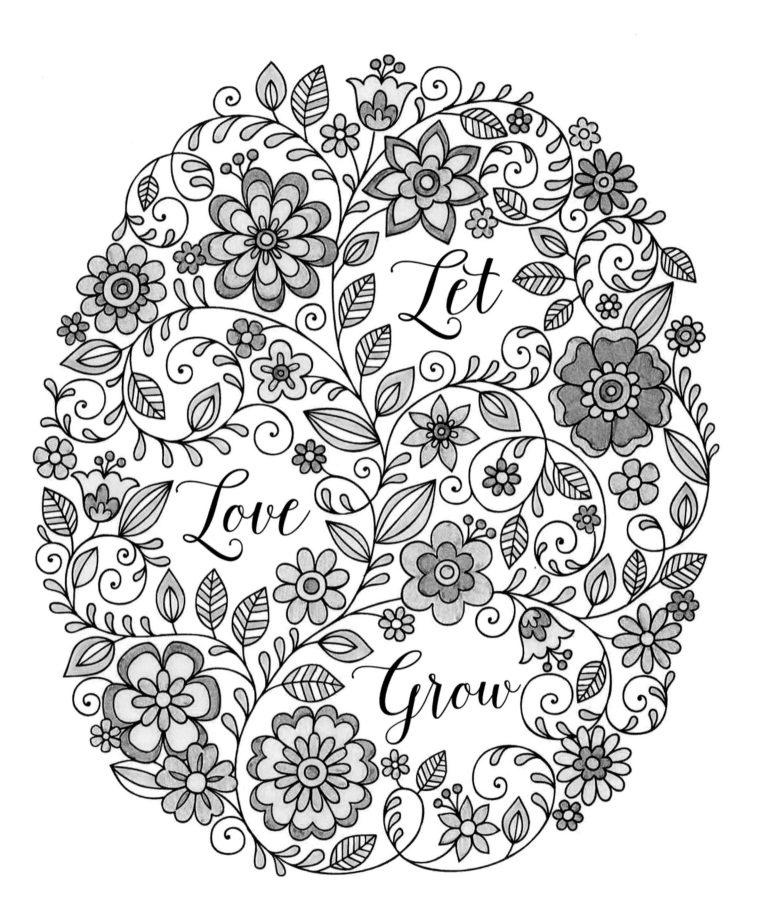

Let

Love

Grow

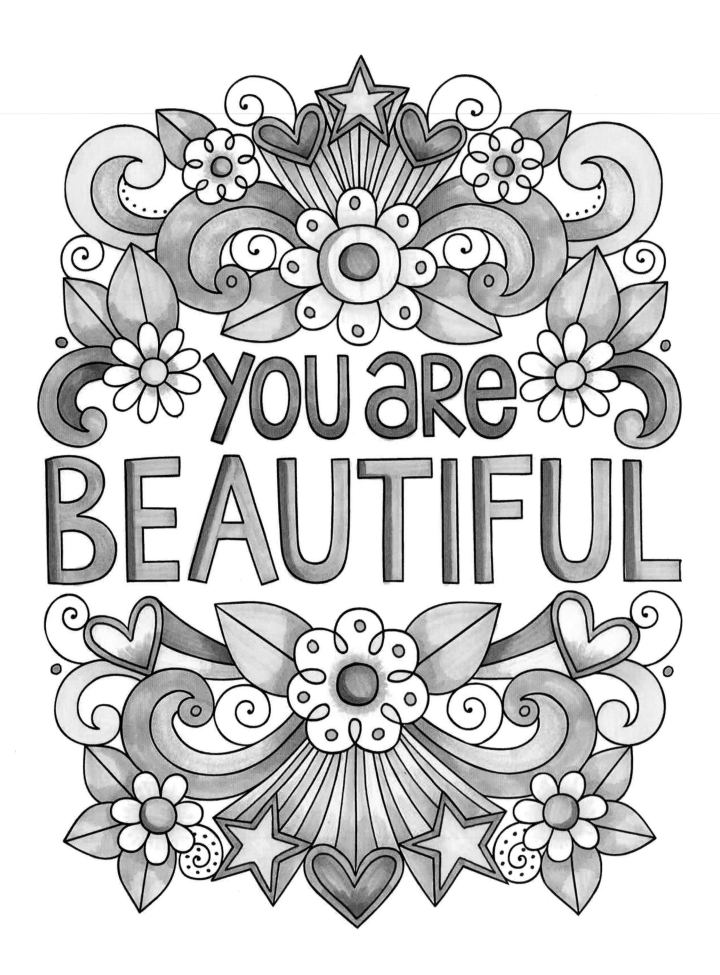

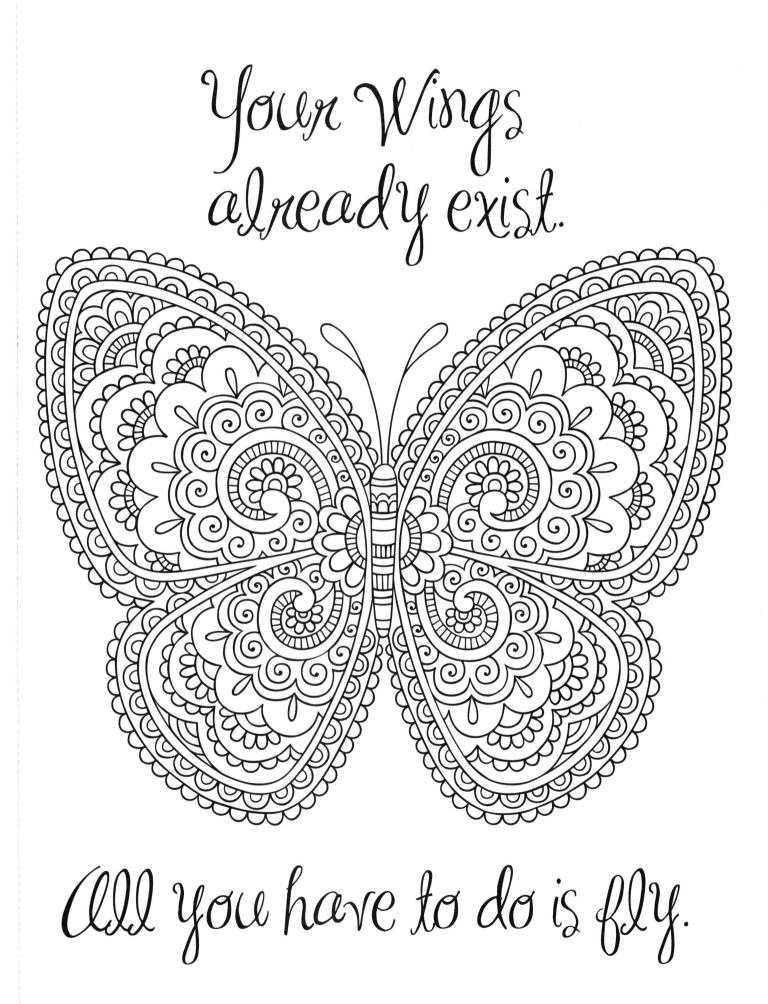

Your Wings
already exist.

All you have to do is fly.

Always be yourself,

express yourself,

have faith in yourself,

do not go out and look for

a successful personality

and duplicate it.

—Bruce Lee

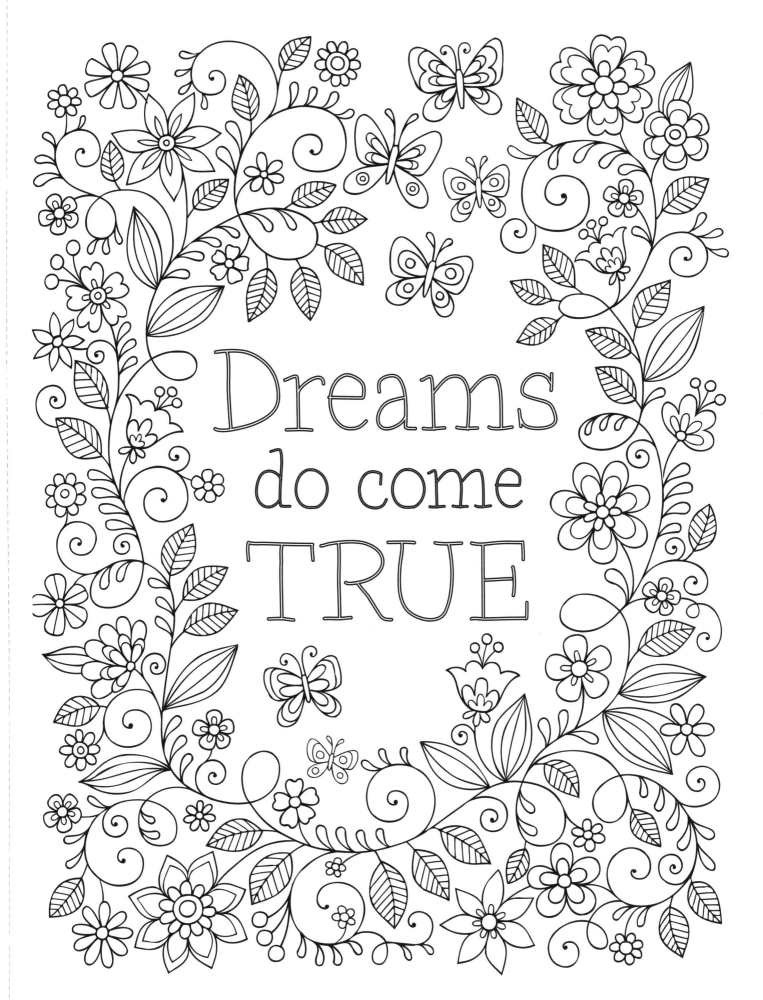

Remember that your natural state is joy.

—Wayne Dyer

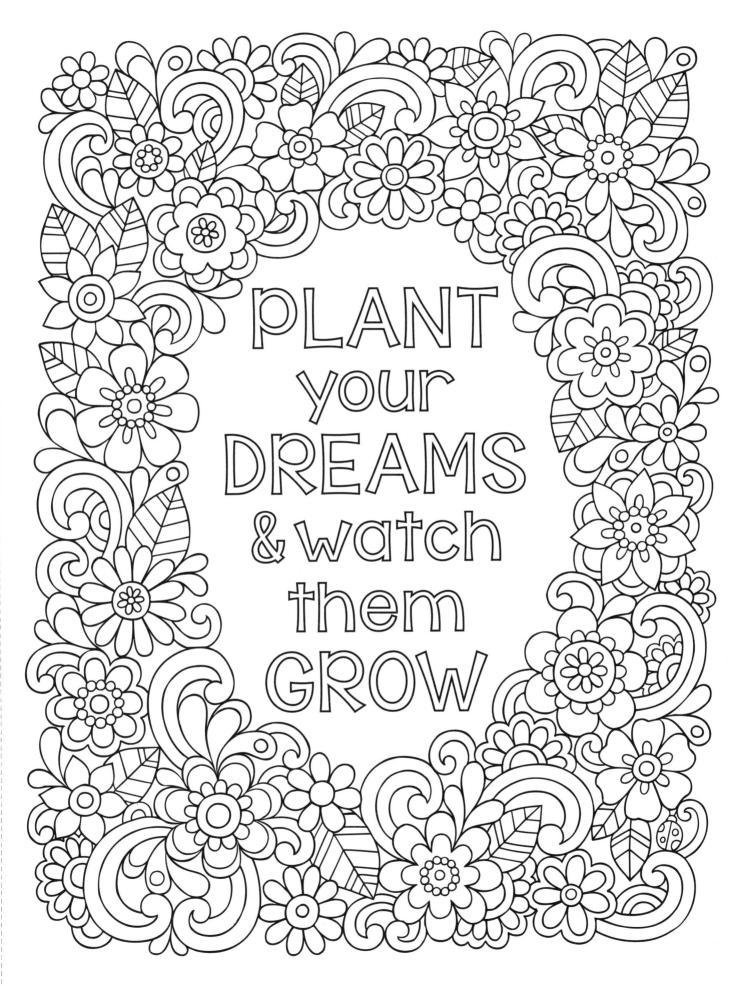

PLANT your DREAMS & watch them GROW

Creativity takes courage.

−Henri Matisse

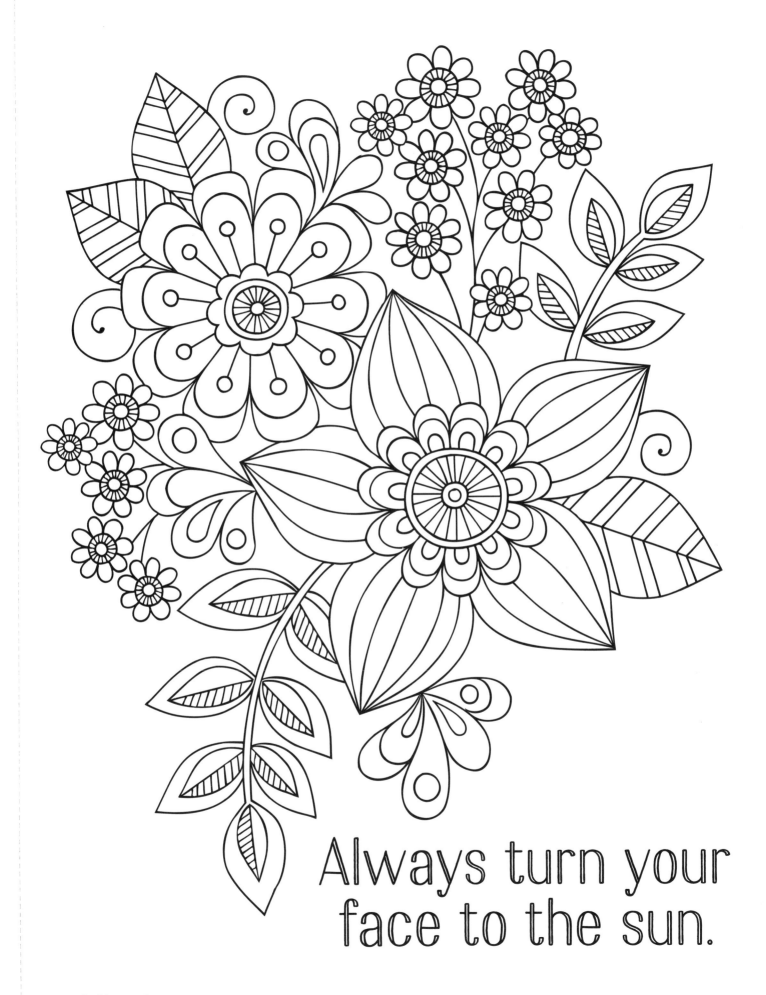

Always turn your
face to the sun.

Whatever you do, be different.

—Unknown

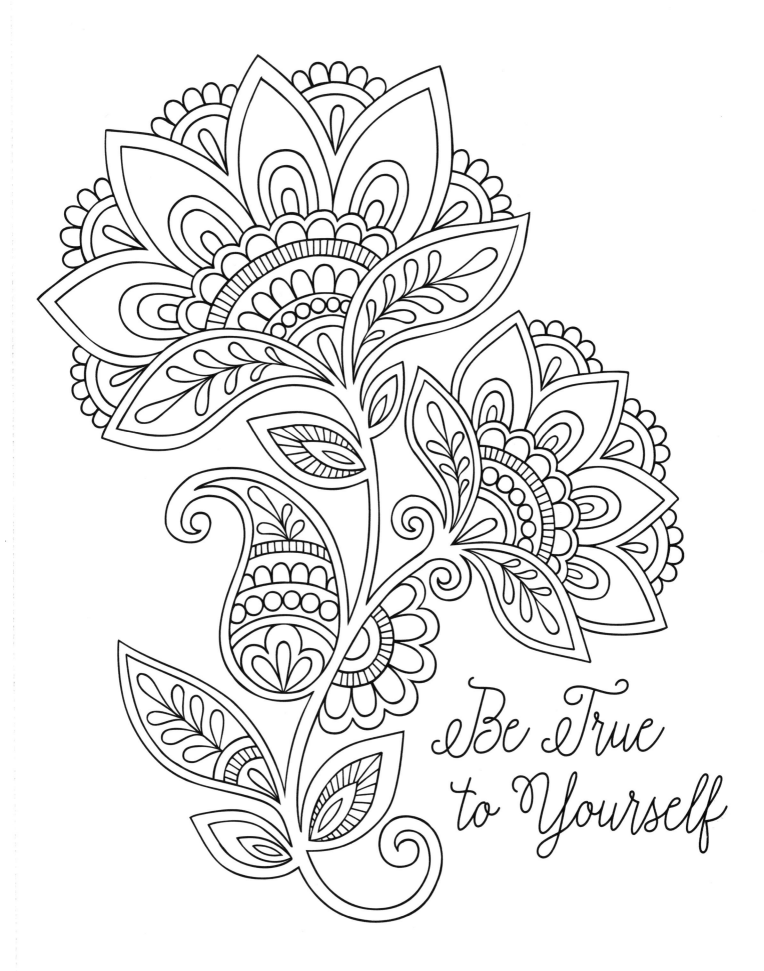

Be True to Yourself

It is the sweet,

simple things of life

which are the real ones after all.

—Laura Ingalls Wilder

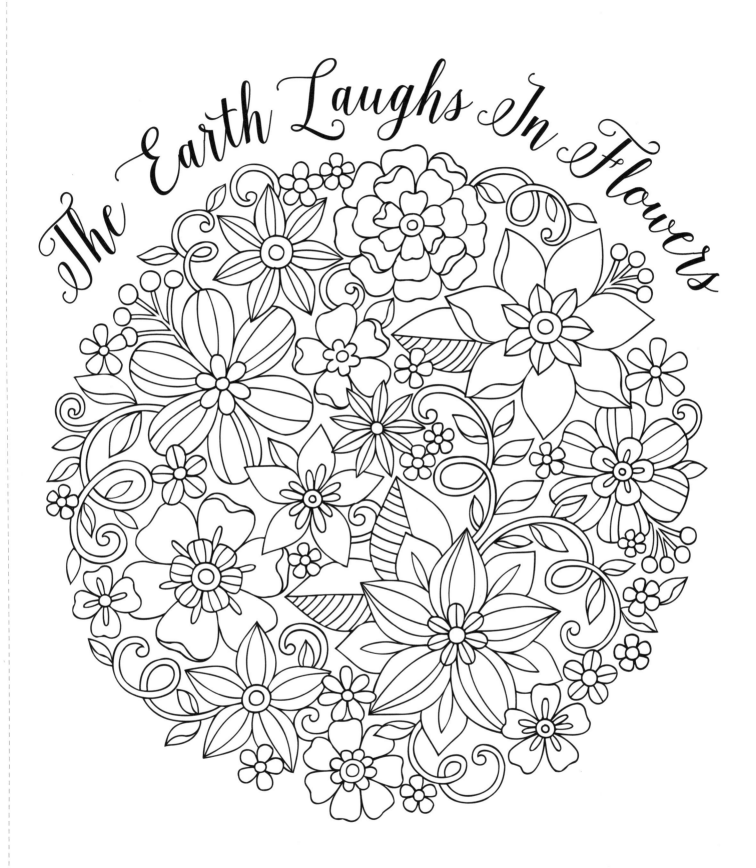

The Earth Laughs In Flowers

–Ralph Waldo Emerson

So plant your own garden and decorate your own soul,

Instead of waiting for someone to bring you flowers.

—Veronica A. Shoffstall, *Comes the Dawn*

Blossom

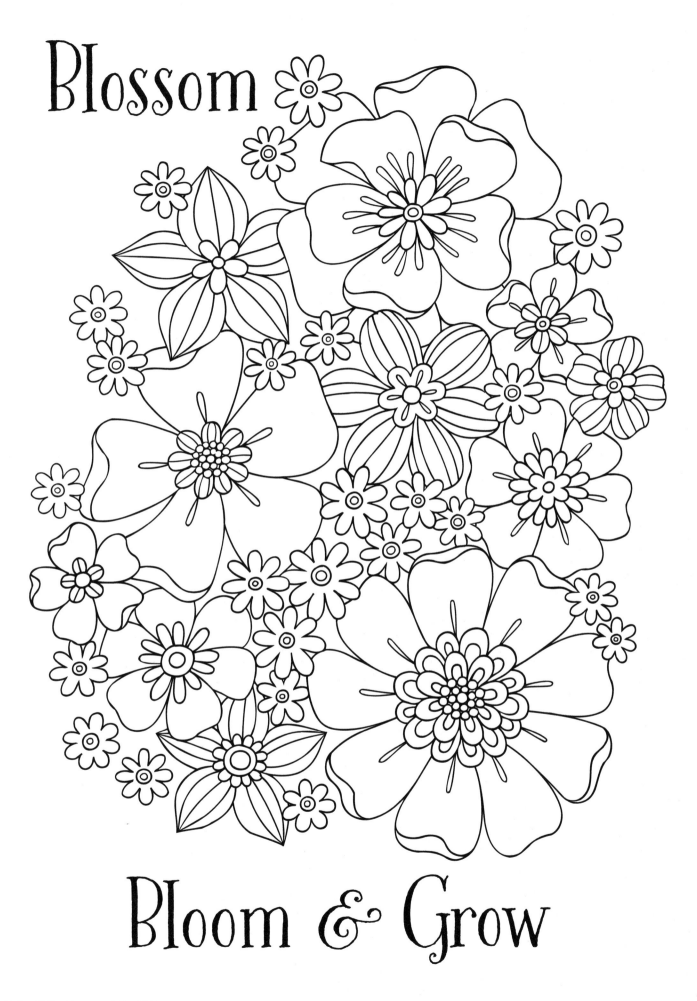

Bloom & Grow

Why not go out on a limb?

That's where the fruit is.

—Unknown

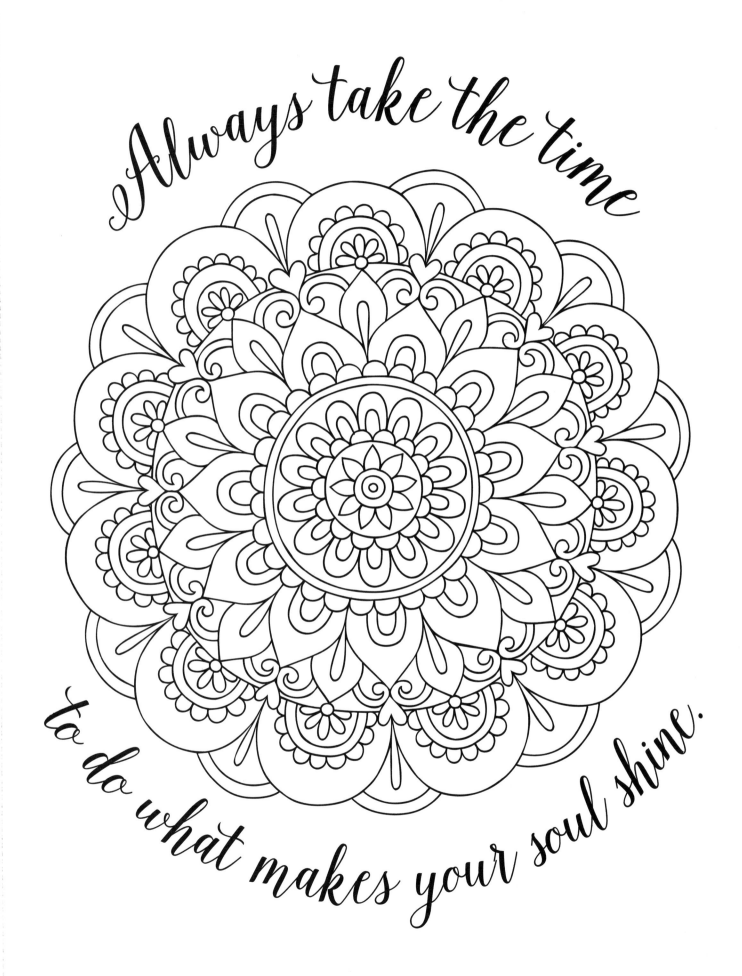

Out of difficulties grow miracles.

—Jean de la Bruyere

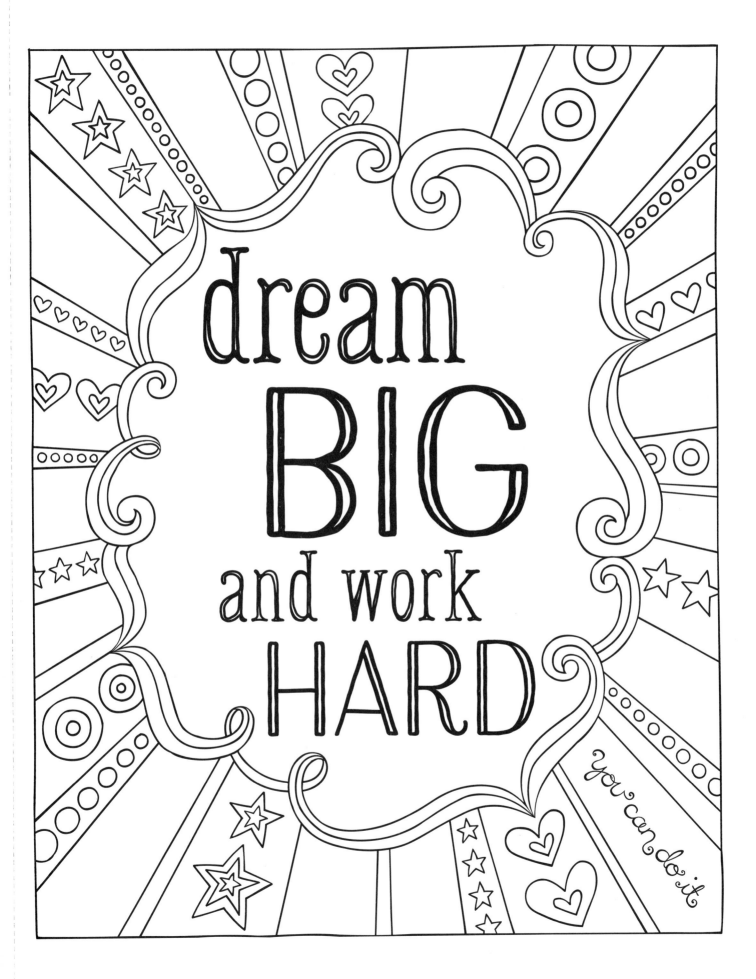

Live your beliefs and you can turn the

world around.

—Henry David Thoreau

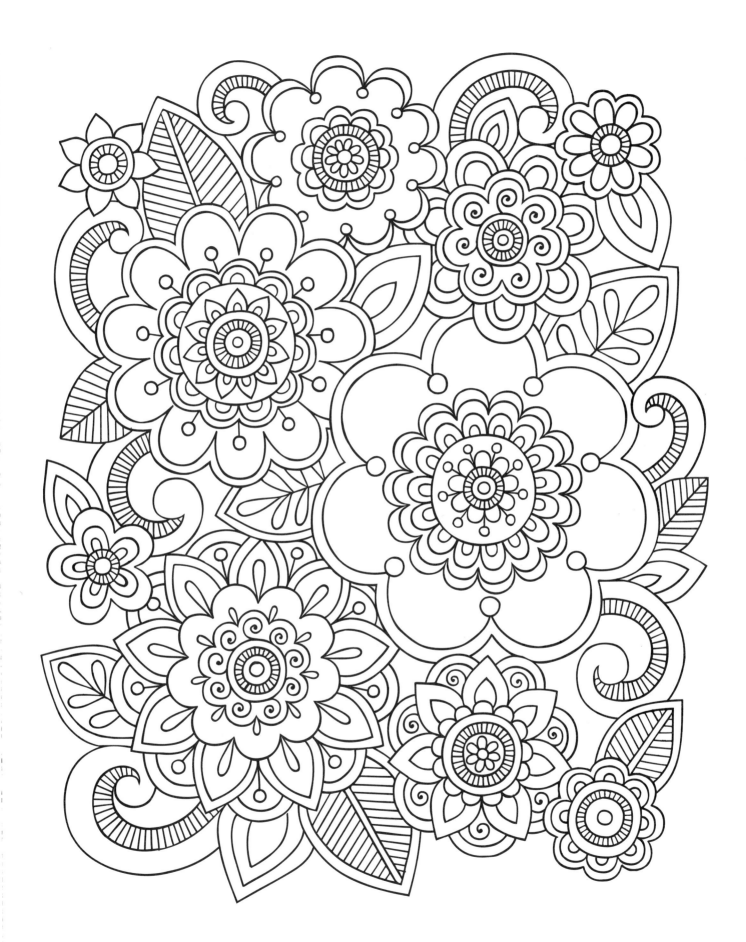

Within you there is a stillness and a sanctuary

to which you can retreat at any time

and be yourself.

—Hermann Hesse

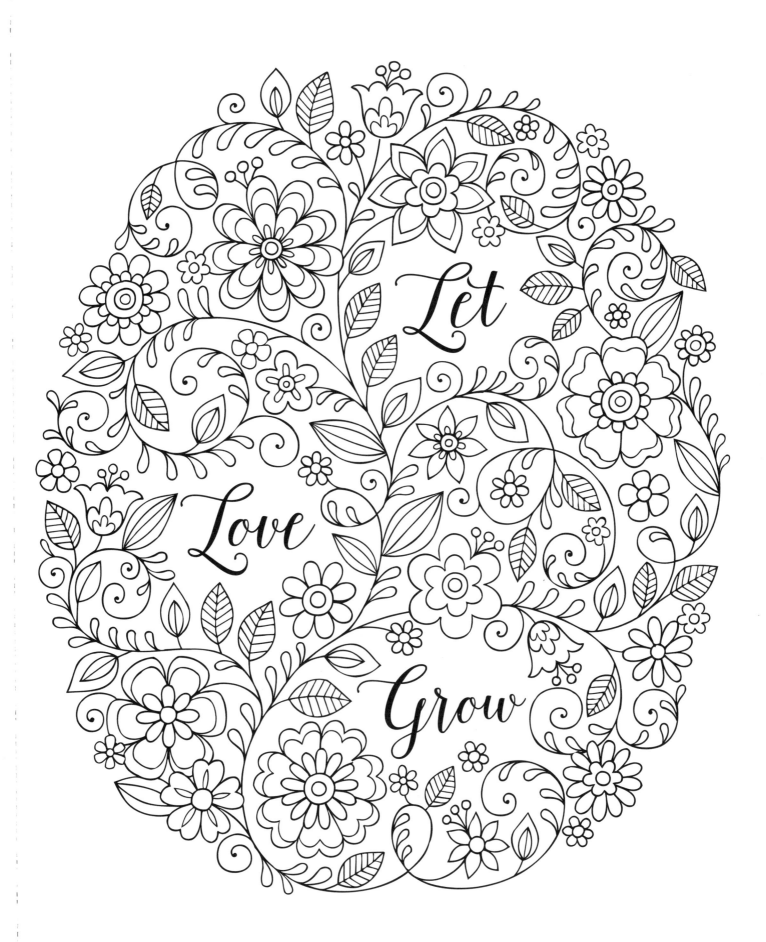

Let

Love

Grow

You must live in the present,

launch yourself on every wave,

find your eternity in each moment.

—Henry David Thoreau

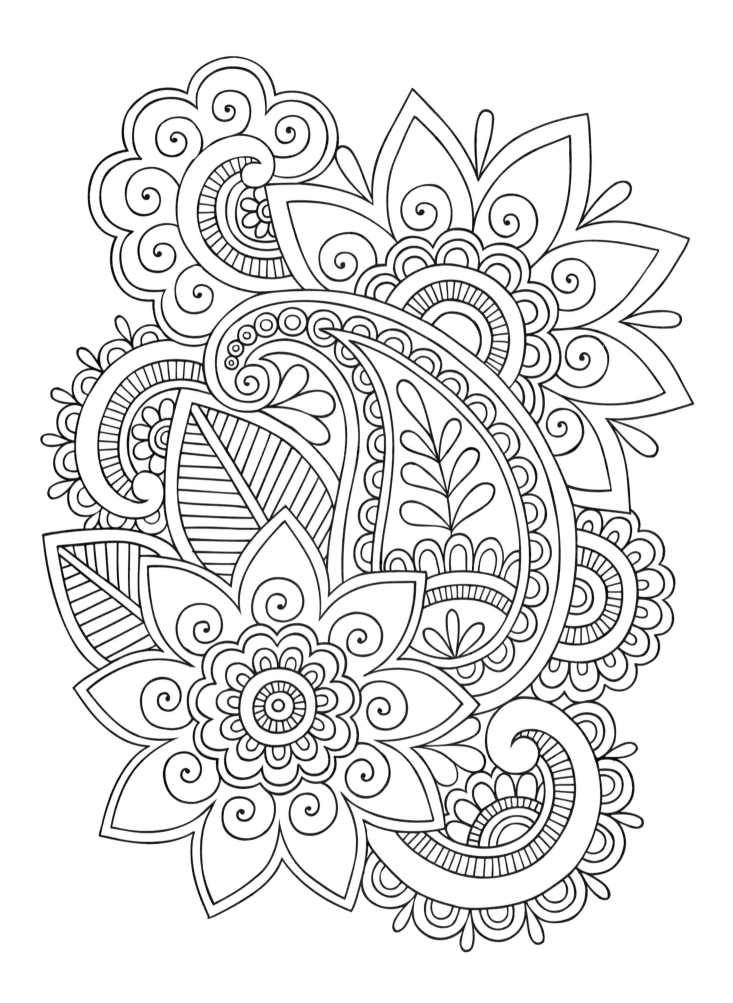

Do not stop thinking of life as an adventure.

—Eleanor Roosevelt

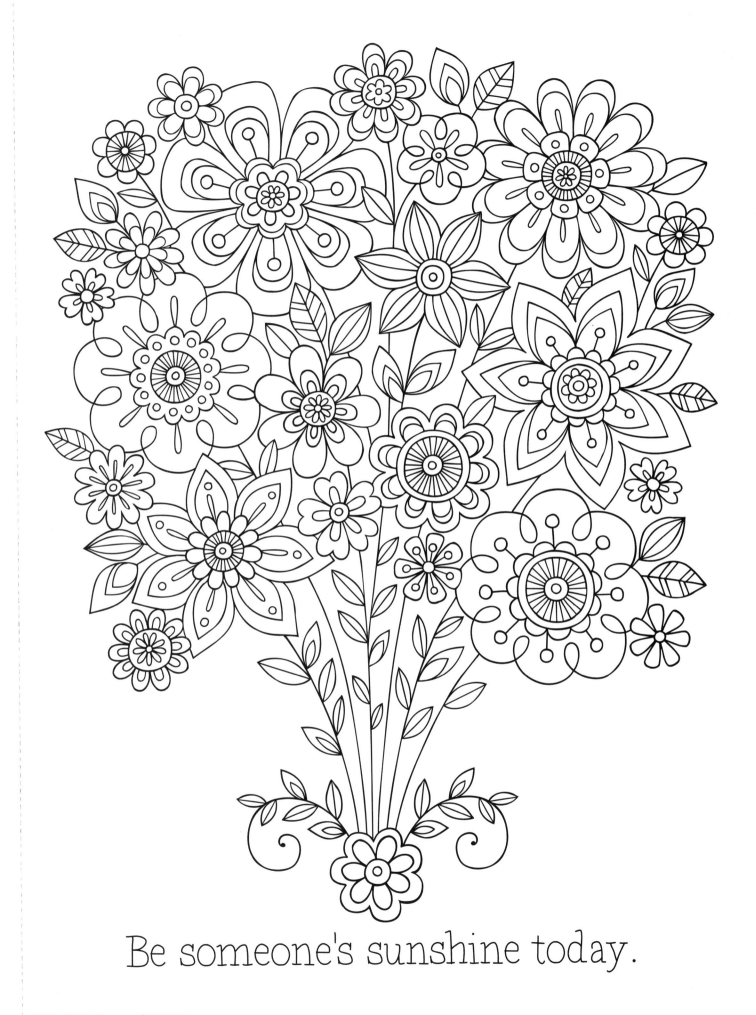

Be someone's sunshine today.

Where flowers bloom,

so does hope.

—Lady Bird Johnson

The best way to pay for a lovely

moment is to enjoy it.

—Richard Bach

Be Amazing Today

Don't let the noise of others' opinions drown

out your own inner voice.

—Steve Jobs

Be the First to Smile

Happiness blooms from within.

—Unknown

Scatter Kindness

Hold hands, not grudges.

—Unknown

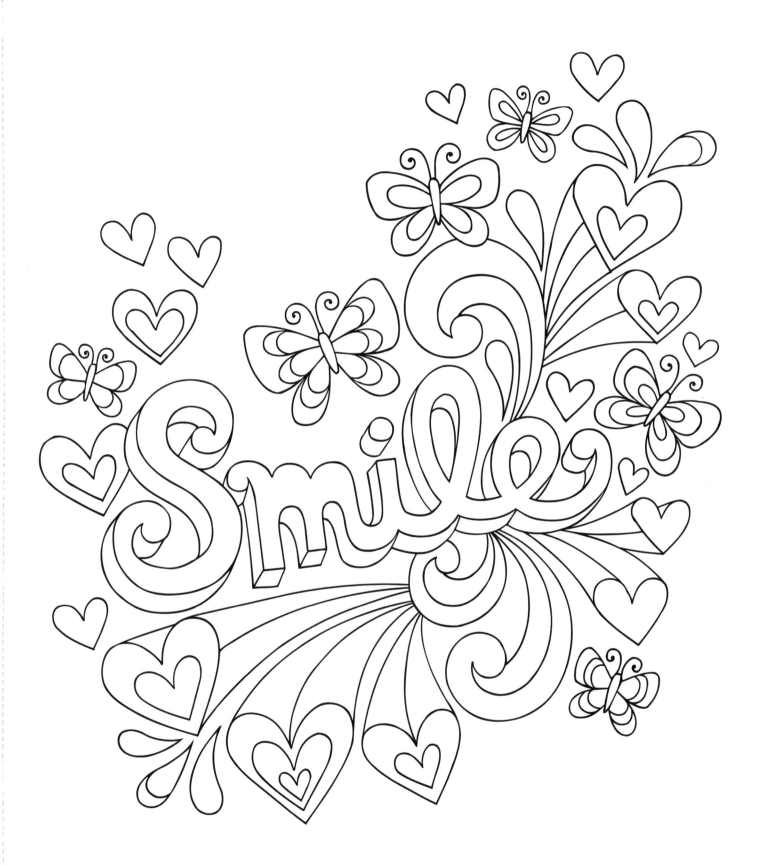

Let your smile change

the world, but don't let

the world change your smile.

—Unknown

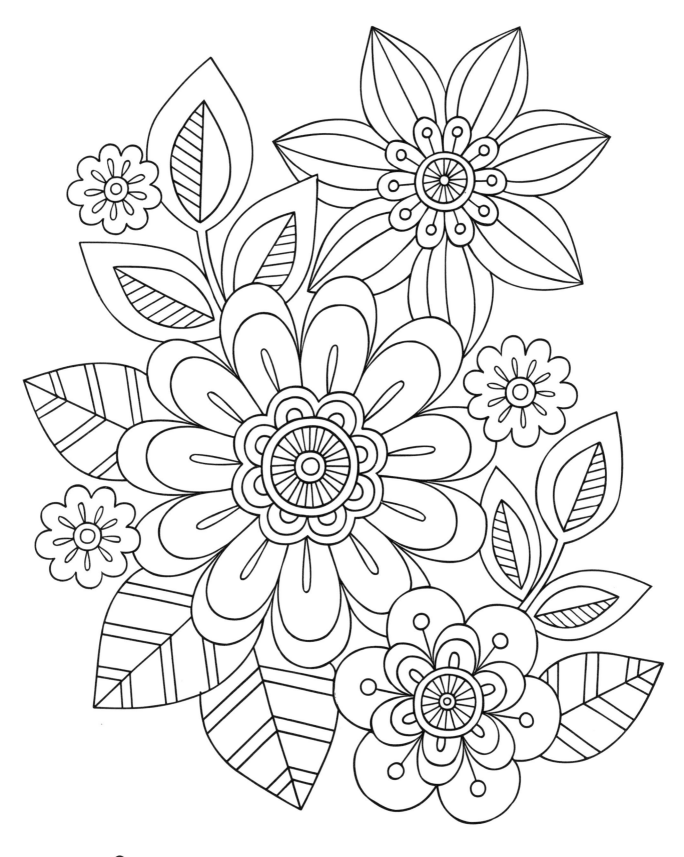

Today is your day to shine

Beauty attracts the eye,

but personality captures the heart.

—Unknown

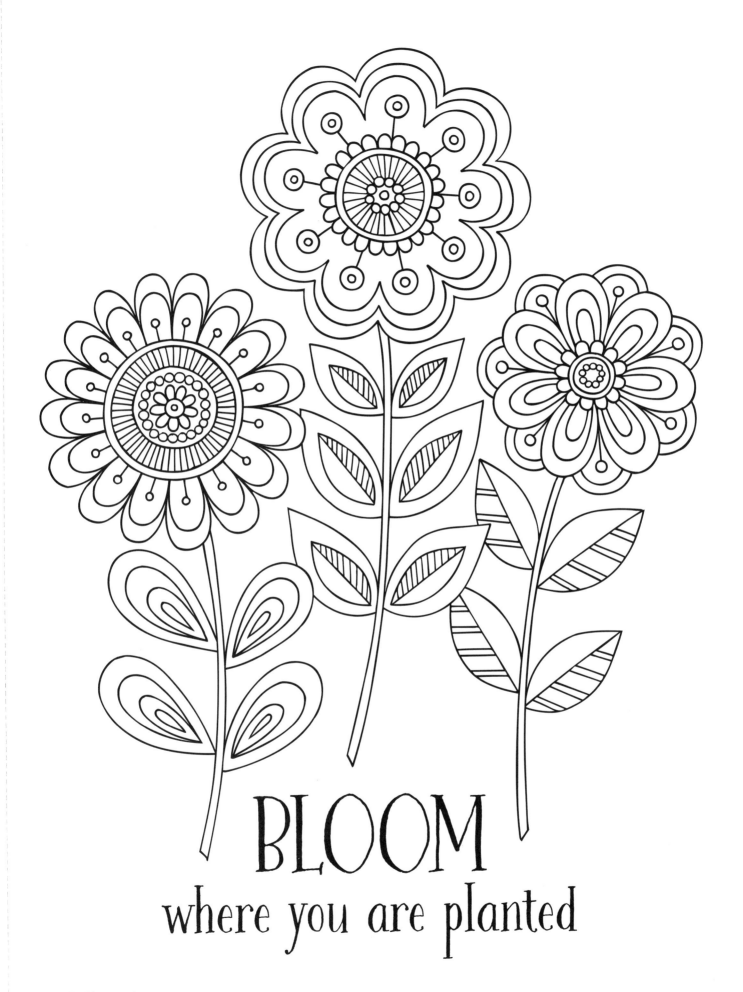

BLOOM
where you are planted

Flowers don't worry about

how they're going to bloom.

They just open up and turn toward the light,

and that makes them beautiful.

—Jim Carrey

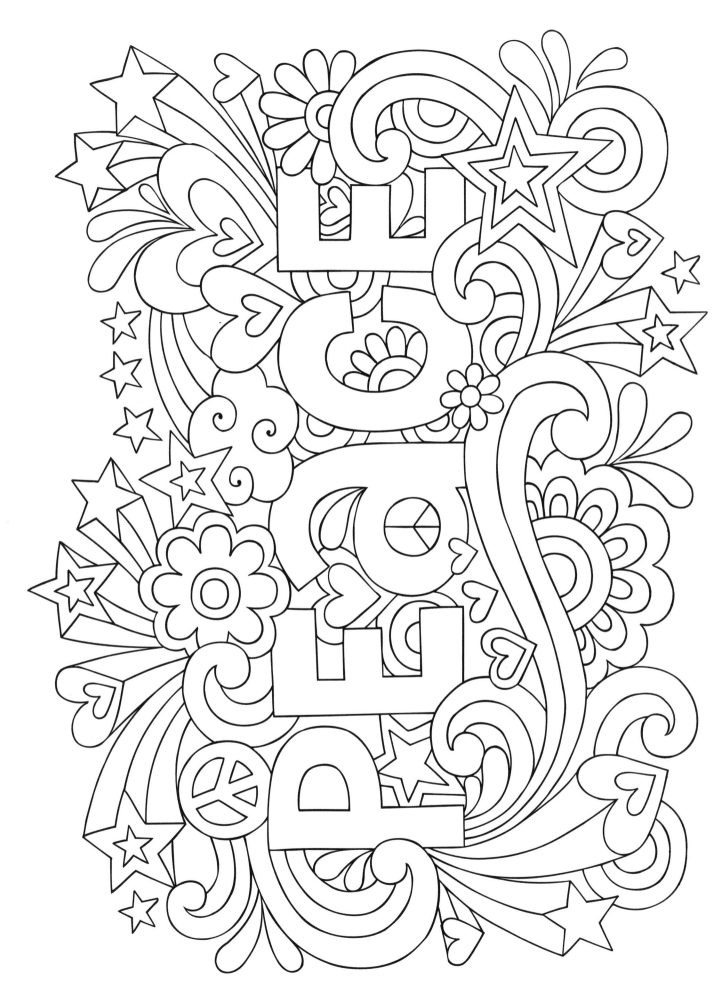

Nothing can bring you peace but yourself.

—Ralph Waldo Emerson

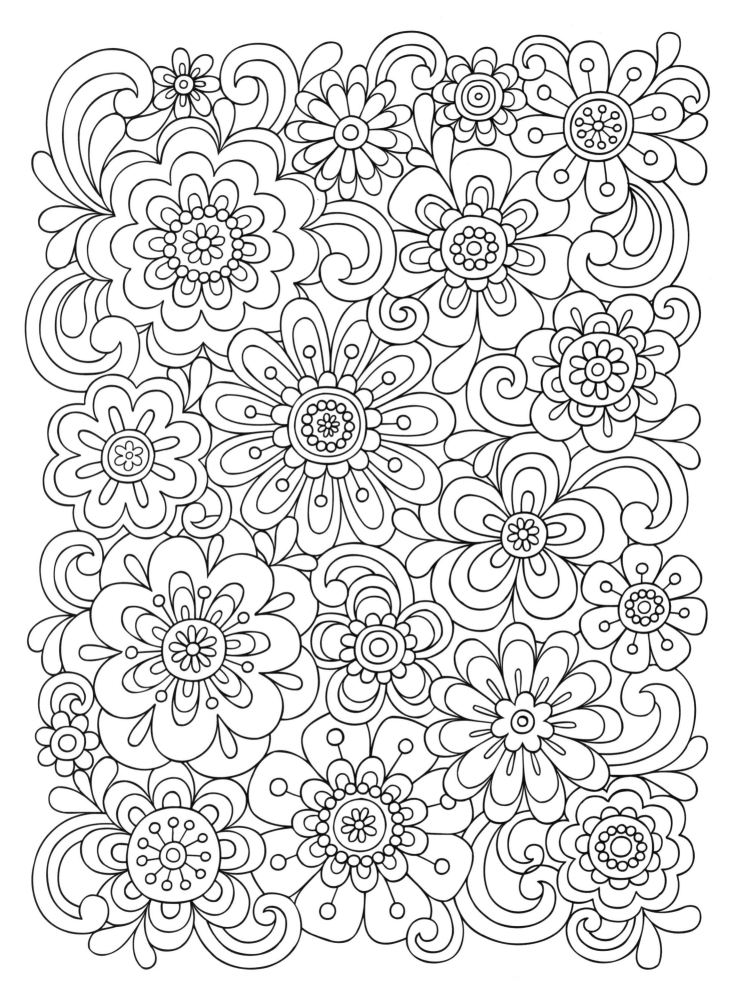

You are built, not to shrink down to less,

but to blossom into more.

—Oprah Winfrey

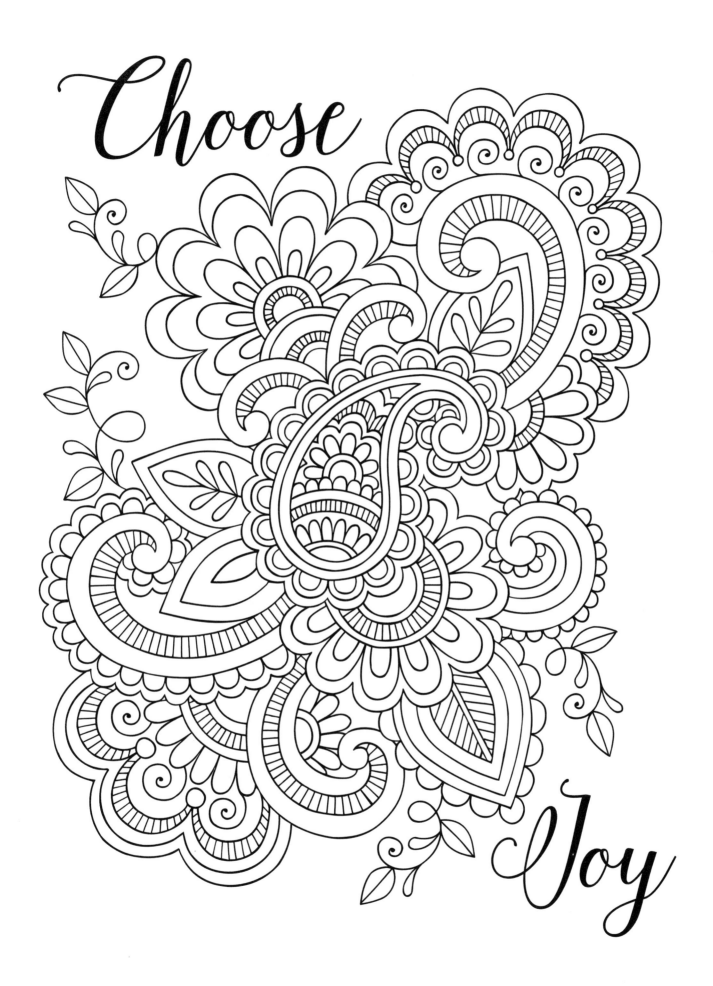

Live your truth.

Express your love.

Share your enthusiasm.

Take action towards your dreams.

Walk your talk.

Dance and sing to your music.

Embrace your blessings.

Make today worth remembering.

—Steve Maraboli

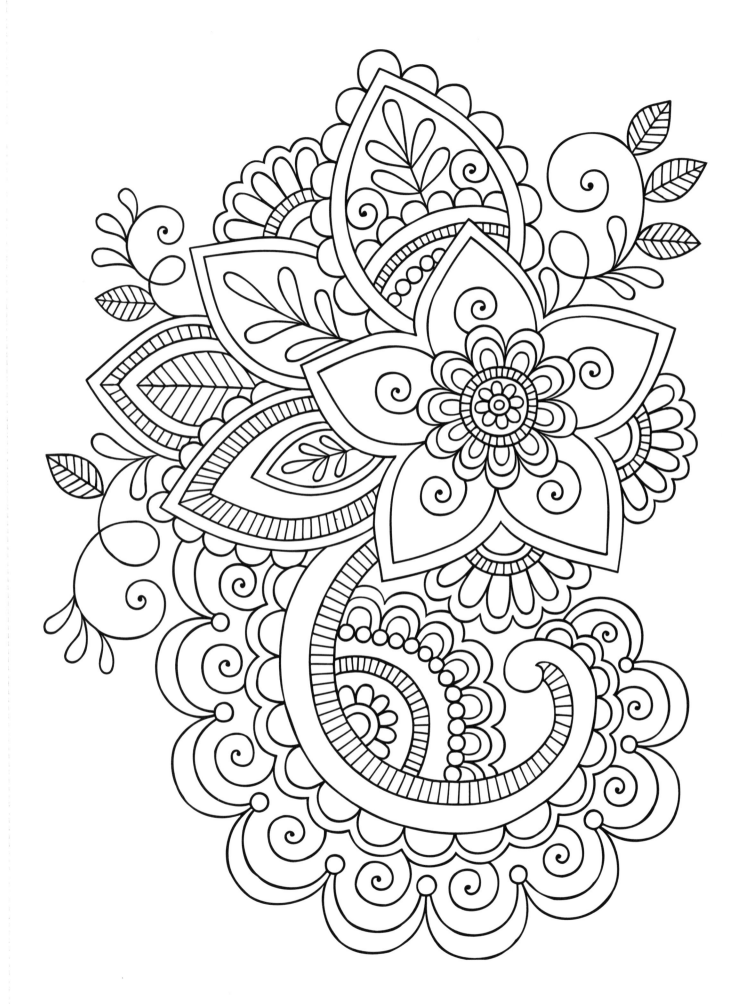

I may not have gone where I intended to go, but I think

I have ended up where I intended to be.

—Unknown

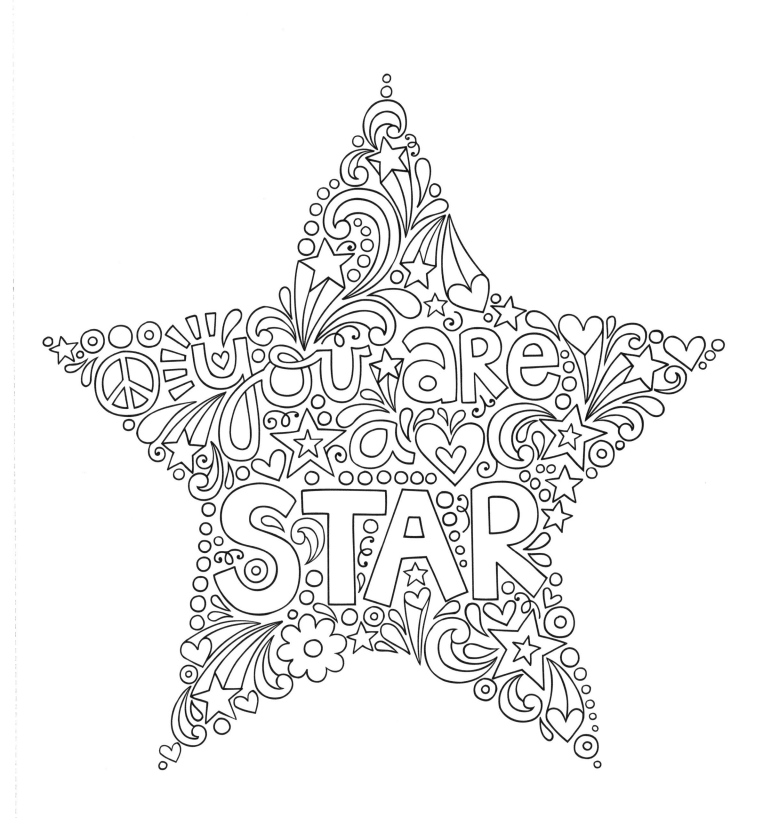

Be so good they can't ignore you.

—Steve Martin

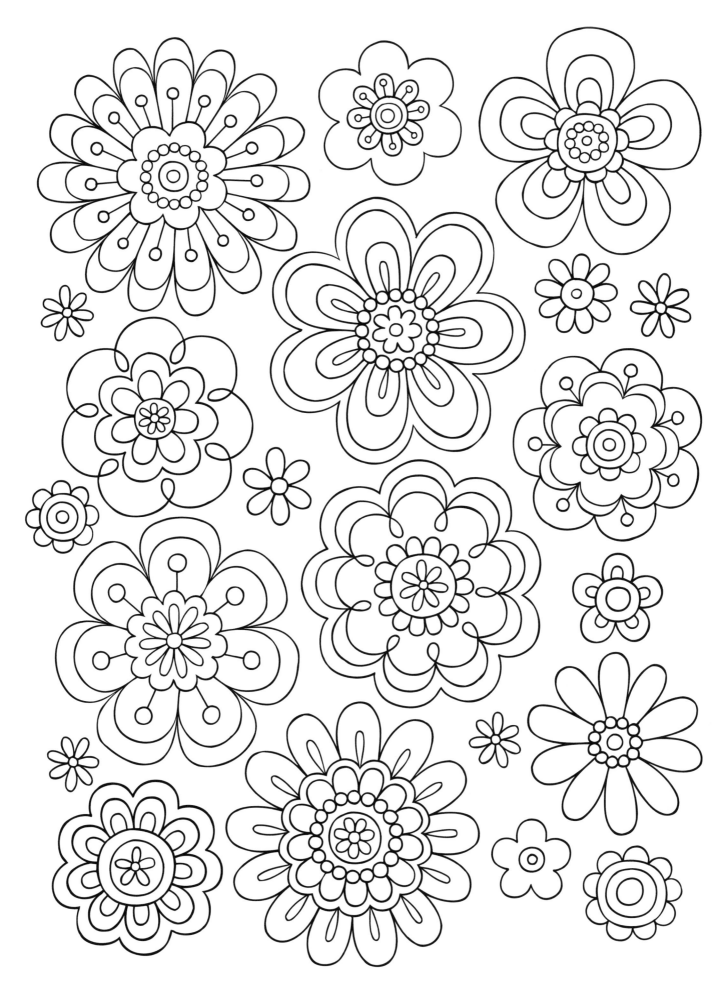

Leave a little sparkle wherever you go.

—Unknown

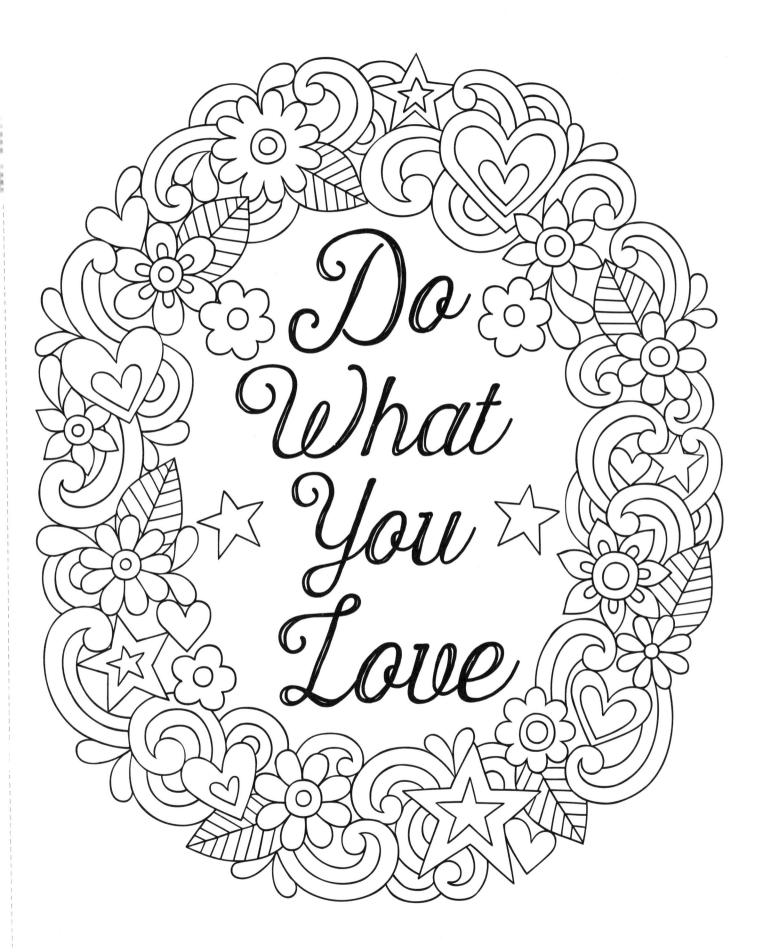

Optimism is the faith that leads to achievement.

Nothing can be done without hope

and confidence.

—Helen Keller

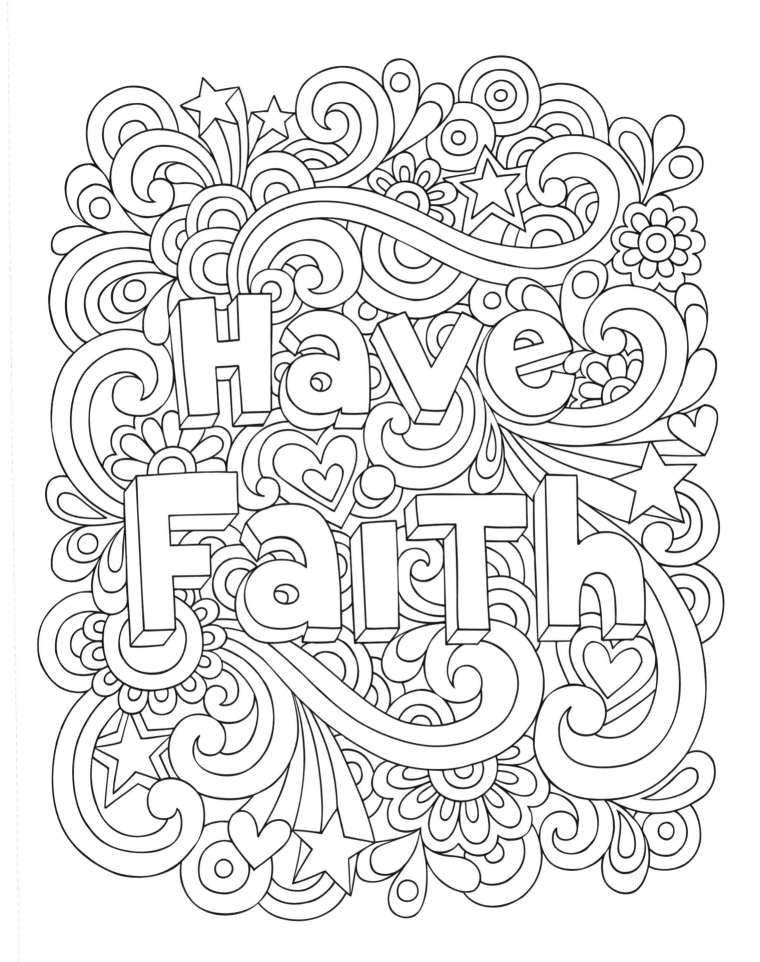

We must have

perseverance and above

all confidence in ourselves.

—Marie Curie

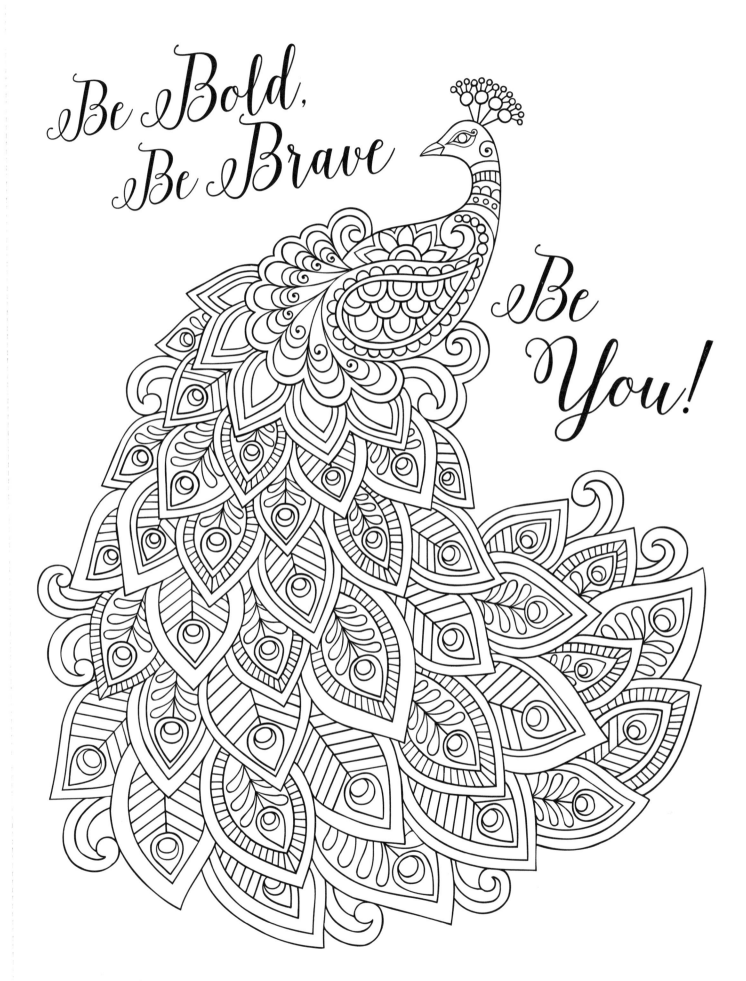

You must give everything

to make your life as beautiful

as the dreams that dance in your

imagination.

—Roman Payne

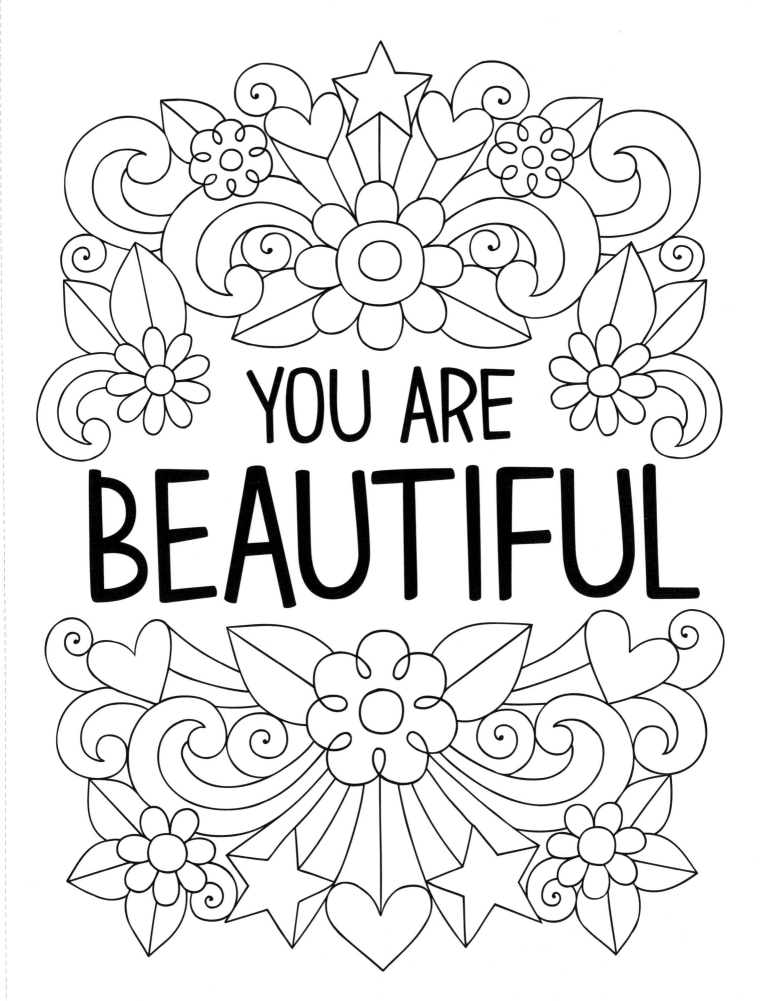

It matters not what someone is born,

but what they grow up to be.

—J. K. Rowling,

Harry Potter and the Goblet of Fire

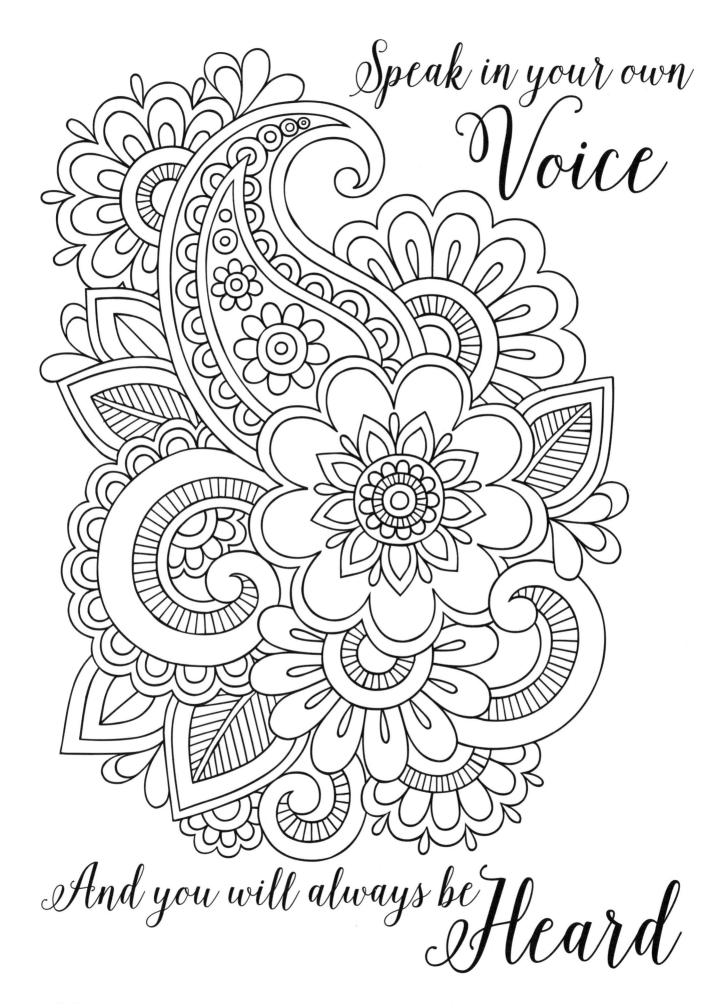

Speak in your own *Voice*

And you will always be *Heard*

Elegance is a glowing inner peace.

—C. JoyBell C.

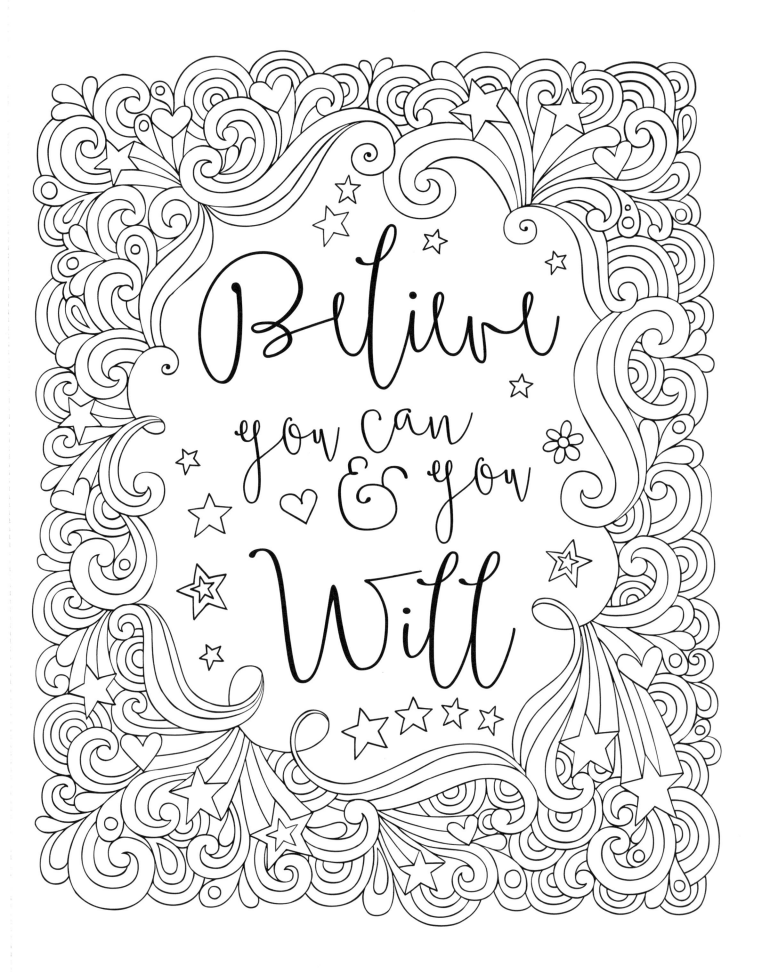

The question isn't who

is going to let me;

it's who is going to stop me.

—Ayn Rand